John Raynes

Draw Faces & Expressions

Series editors: David and Brenda Herbert

A & C Black · London

First published 1982
New style of paperback binding 1997
by A & C Black (Publishers) Limited
35 Bedford Row, London WC1R 4JH

Reprinted 1998, 2001

ISBN 0-7136-4734-5

Printed in Great Britain by Martins the Printers,
Berwick upon Tweed

Contents

Making a start

To draw expressions convincingly (as with drawing anything), you need first to develop and use your powers of observation, and then plenty of practice. Learn to look closely at the faces of all the people you meet, as well as those you persuade to pose for you, and try to understand, for example, what happens to the whole of the head, neck and even shoulders, when someone laughs or frowns. If you represent a frown simply by knitted brows and a downturned mouth, or a smile by crinkling eyes and a mouth turned up at the corners, your drawing will be little more than a cartoon.

Even if you observe carefully, you may not remember what you have seen. So carry a sketchbook with you whenever possible and try to put down on paper something — however sketchy or incomplete — of the faces and expressions you come across. Don't put down what you think *ought* to be there; draw only what you honestly see.

Don't worry too much about the sort of marks you make. Any old marks in the right places will work; the prettiest lines and tones in the wrong places won't work.

Every drawing medium makes its own type of mark; some, like charcoal, can be used boldly, others, such as pen and ink, have to be used with more care. Experiment to find out what suits you. And judge your drawing by whether it records accurately a genuine visual discovery that you have made — not by whether it is neat and tidy.

On the whole, it is better not to rub out too much; if you leave construction lines in, you will have a living record of your exploration.

Study the drawings of established masters, in preference to those of contemporaries, unless you are sure of a contemporary's quality. There is some very good drawing about, and some very bad; time has sorted out the best of the past.

Although much can be learned by practice and from books, a teacher can be a great help. If you get the chance, don't hesitate to join a class; even one evening a week can do a lot of good.

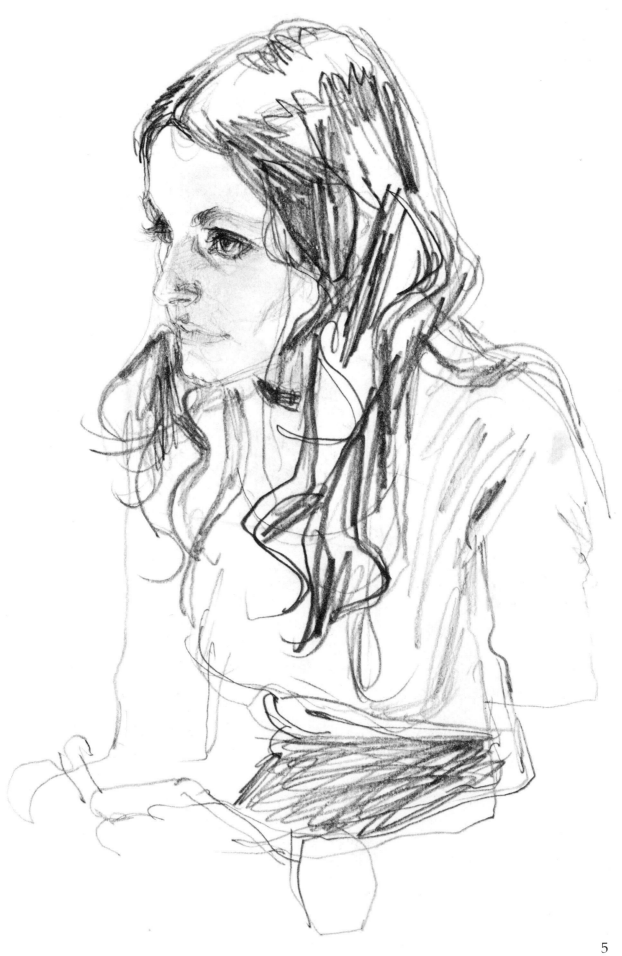

What to draw with

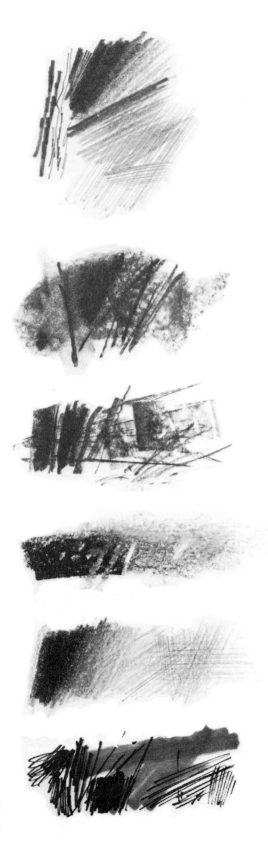

Pencils are the most versatile drawing instruments generally in use. They are graded according to hardness, from 8H (the hardest) through 7H, 6H, 5H, 4H, 3H, 2H, H; then HB & F medium grade; then B through 2B, 3B, 4B, 5B to 6B (the softest).

It is important when selecting a grade of pencil to realise that the sort of mark it makes will depend on the surface you draw on. For example, the drawings on pages 30–33 were made with a 6H — which on cartridge paper would need a lot of pressure to produce more than a pale grey line, and would not smudge at all. They look as if they were made with a 5B or 6B because the surface was a board coated with acrylic gesso, which dries hard.

In general, thin, smooth or soft papers need a softer pencil; thick, rough or hard papers can take harder pencils.

Charcoal is soft and black on most surfaces and excellent for non-detailed, bold sketches. It is easily smudged (or erased entirely) which makes it easy to alter, either intentionally or accidentally. A finished drawing needs preserving by a spray fixative.

Conté crayons, wood cased or in solid sticks, are usually available in various degrees of hardness and in black, white and two browns. Although pleasant, they are difficult to handle; easily smudged, they are not easily erased.

Pastels and chalks (available in a wide range of colours) are softer than Conté. Light and dark tones can be mixed together to give very subtle shadings; they also need to be spray-fixed.

Wax pencils and crayons are much used today and are available in a wide range of quality and forms. The best of them will mix on the paper for smooth and subtle gradations of tone and colour like pastels, but can be sharpened for precision. Though not easily erased, they can be scraped off smooth, hard surfaces.

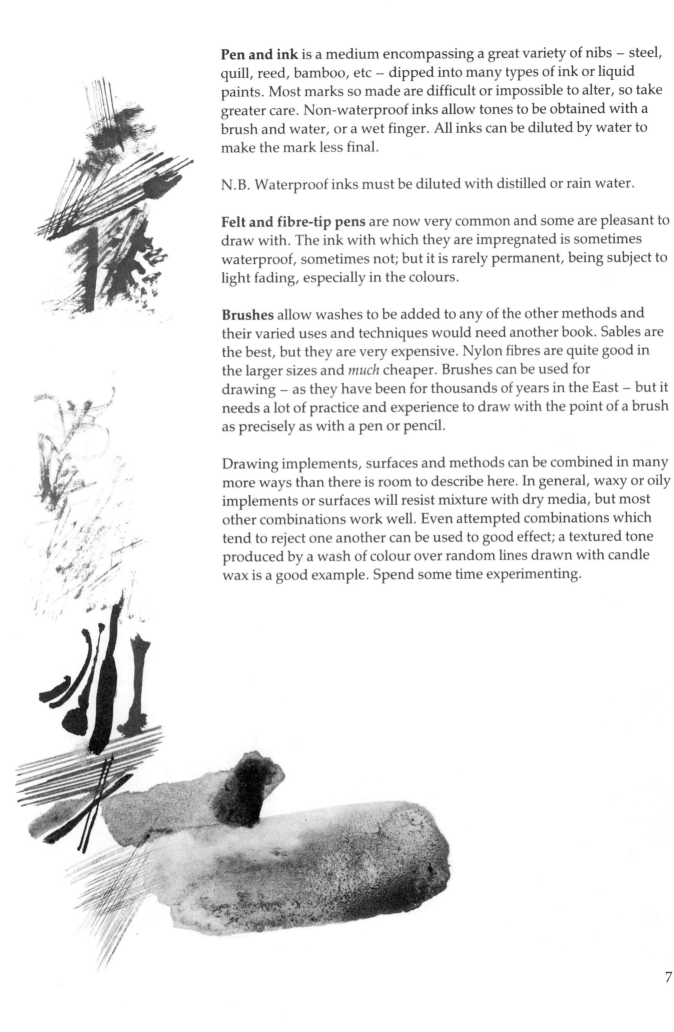

Pen and ink is a medium encompassing a great variety of nibs – steel, quill, reed, bamboo, etc – dipped into many types of ink or liquid paints. Most marks so made are difficult or impossible to alter, so take greater care. Non-waterproof inks allow tones to be obtained with a brush and water, or a wet finger. All inks can be diluted by water to make the mark less final.

N.B. Waterproof inks must be diluted with distilled or rain water.

Felt and fibre-tip pens are now very common and some are pleasant to draw with. The ink with which they are impregnated is sometimes waterproof, sometimes not; but it is rarely permanent, being subject to light fading, especially in the colours.

Brushes allow washes to be added to any of the other methods and their varied uses and techniques would need another book. Sables are the best, but they are very expensive. Nylon fibres are quite good in the larger sizes and *much* cheaper. Brushes can be used for drawing – as they have been for thousands of years in the East – but it needs a lot of practice and experience to draw with the point of a brush as precisely as with a pen or pencil.

Drawing implements, surfaces and methods can be combined in many more ways than there is room to describe here. In general, waxy or oily implements or surfaces will resist mixture with dry media, but most other combinations work well. Even attempted combinations which tend to reject one another can be used to good effect; a textured tone produced by a wash of colour over random lines drawn with candle wax is a good example. Spend some time experimenting.

What to draw on

Ordinary, inexpensive paper is often as good as anything else; for example, brown and buff wrapping paper (Kraft paper) and lining for wallpaper have surfaces which are particularly suitable for charcoal and soft crayons.

Ledger Bond paper ('cartridge' in the UK), the most usual drawing paper, is available in a variety of surfaces — smooth, 'not surface' (semi-rough), rough.

'Coated' papers and boards have a thin top layer of china clay which makes them very smooth. They are intended for fine pen-and-ink work and do not readily accept pencil, chalk and pastel. Washes tend to dry with hard edges which can be utilised for interesting textures (see page 10).

Any surface (cheap card, hardboard etc.) can be made into a pleasant drawing surface, especially for pencil, by painting onto it a prepared gesso or painting ground (see page 6). Such a surface can be smoothed as required with fine emery paper and has the added advantage that erasures can be made by painting out.

Watercolour papers also come in various grades of smoothness. They are thick, high quality papers, expensive but pleasant to use, and take washes of colour well.

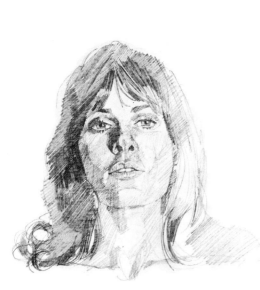

2H pencil on acrylic gesso ground (smoothed with fine emery paper)

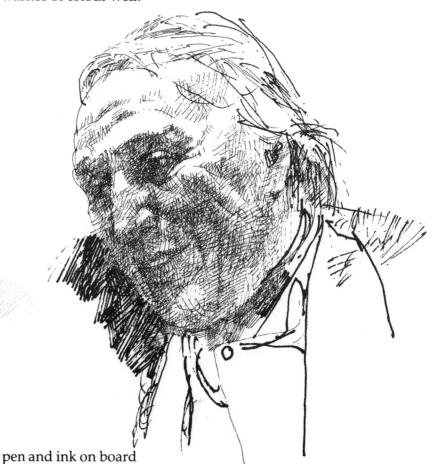

pen and ink on board

Ingres paper is mainly for pastel drawings. It has a soft, furry surface and is made in many light colours — grey, pink, blue, buff, etc.

Sketchbooks, made up from most varieties of papers, are available — some have several types of paper in the one book. One with thin, smooth cartridge is likely to be the most gererally useful. An improvised sketchbook can be just as good as a bought one — or better. Find two pieces of thick card, sandwich a stack of paper, preferably of different kinds, between them and clip together at either end.

Lay-out pads make good sketchbooks. Although their covers are not stiff, you can easily insert a stiff piece of card to act as a firm backing to your drawing. The paper is semi-transparent, but this can be useful — almost as tracing paper — if you want to make a new, improved version of your last drawing.

Drawings showing the use of different surfaces appear here and on the following two pages.

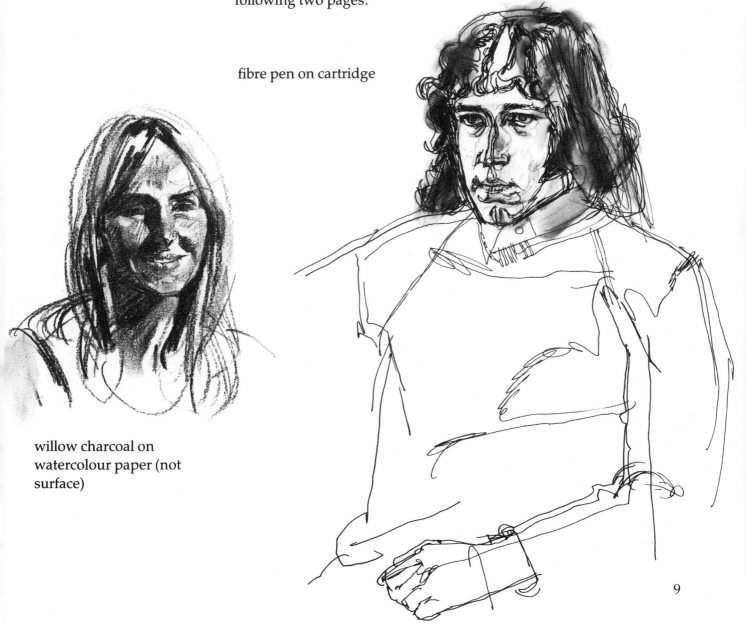

fibre pen on cartridge

willow charcoal on
watercolour paper (not
surface)

9

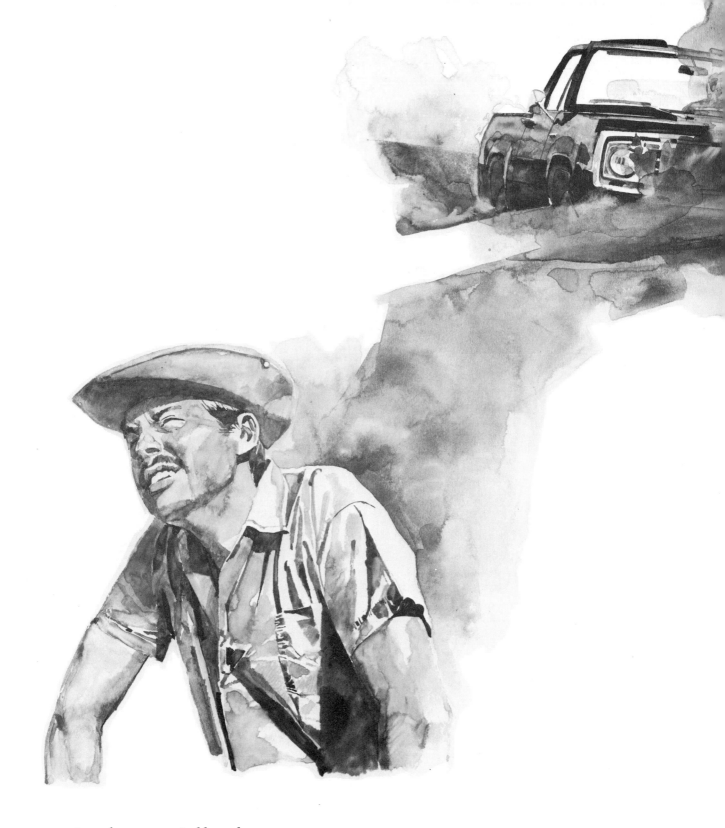

water colour on coated board
(picture reproduced by kind
permission of *Oxford
University Press*)

fibre pen on cartridge

Perspective and structure

The following basic 'rules' of perspective are as relevant to drawing heads and expressions as to drawing anything else:

All parallel lines directly opposite you — at right angles to your line of vision — remain parallel.

All horizontal lines that are in fact parallel but go away from you will appear to converge at eye-level at the same vanishing point on the horizon. Lines *above* your eye level will seem to run downwards; lines *below* your eye level to run upwards.

The larger and closer any object is, the bigger the front of it will seem in relation to the back. Its shape will appear foreshortened or distorted.

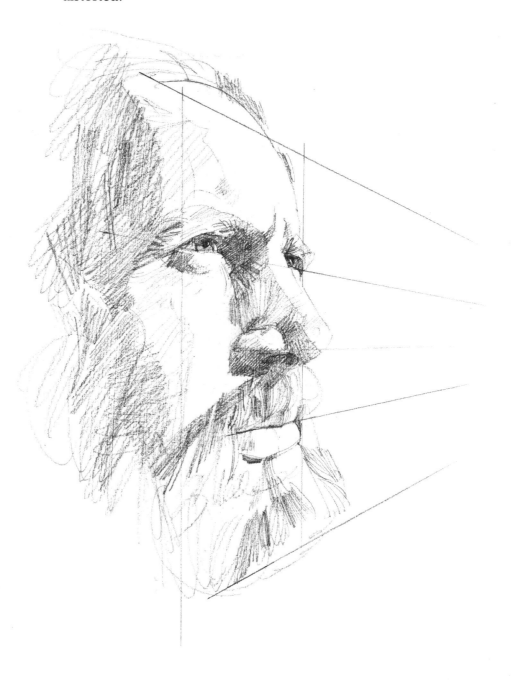

A head can be seen as a series of boxes, made up of the fairly flat planes or surfaces of its structure. These boxes — which are subject to the normal perspective rules — are not precisely right-angled, as the drawings here show; the plane representing the face, for example, is at 90° to the central axis of the head, but the head's widest part is towards the back, and the side planes therefore slope outwards from the front. The parallel lines positioning the facial features must be related to the perspective shape of the front plane — depending on your viewpoint. In perspective these lines will eventually converge, but on an object as small as a human head you will only notice the convergence if you approach very close, as in the more finished drawing below.

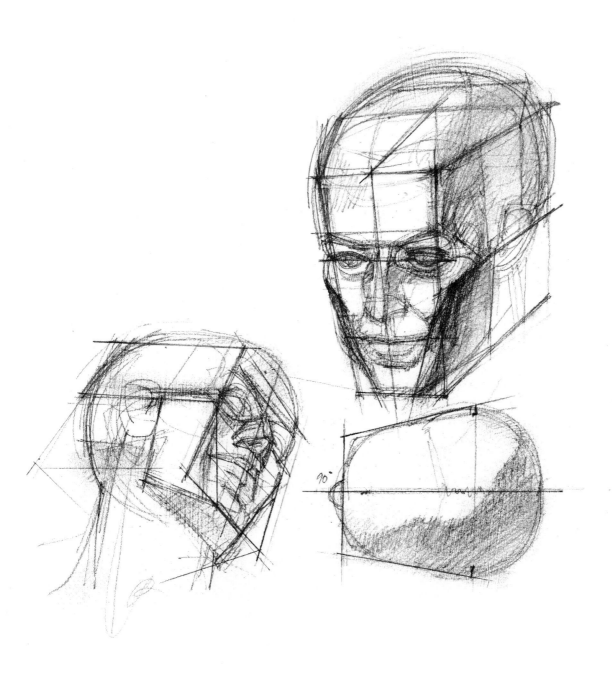

Having absorbed the idea of a head's box structure, try some drawings of a skull — either by copying other drawings like mine here or by sketching direct from a plastic model or real skull. You will learn from this how few formal differences there are between a skull and a living head. Once the spheres of the eyes are positioned and the nose completed by extending the bridge with cartilage (which also forms the nostrils), all that is missing to give the skull life is a comparatively thin layer of muscle and tissue covering the bones.

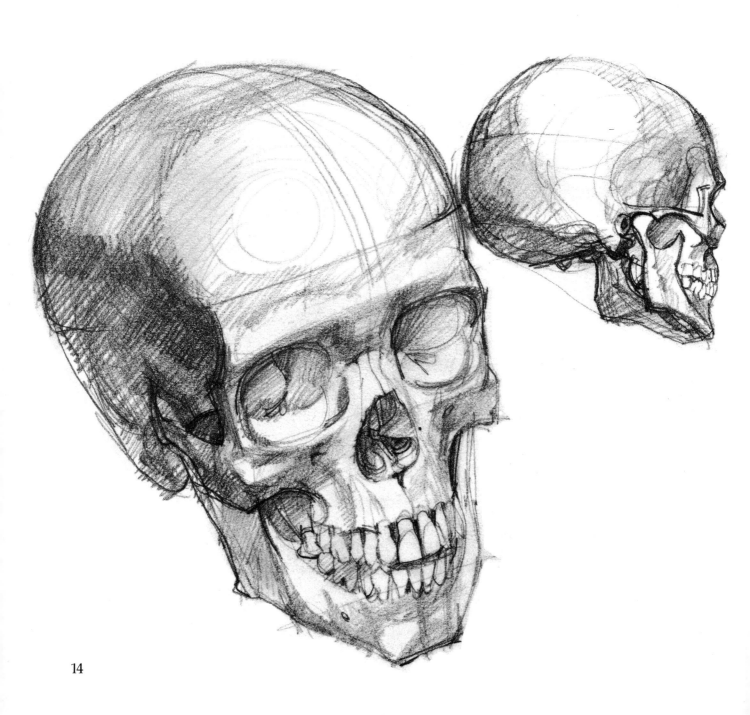

The only really strong muscle is the masseter which clamps the jaw shut: its bulks fills the space under the cheekbone (zyomatic), rounding out the angle of the jaw. All other muscles are muscles of expression (though some assist such other functions as speech and mastication too) and only need to be strong enough to pull the facial tissues into different shapes.

Except in very plump faces the bony structure is always evident — the cheekbone being particularly important. Every skull, like every face, is different; and only if you sense the skull beneath the skin of the living face you draw — and get its proportions right — will the soft features add up to a likeness of that particular person.

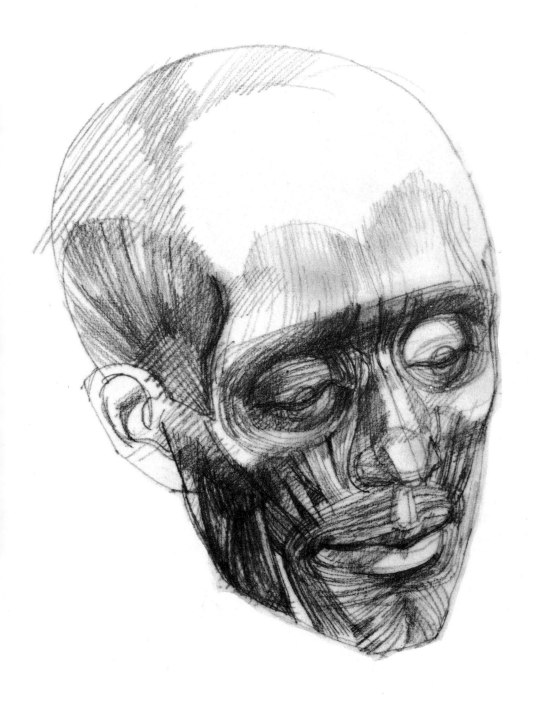

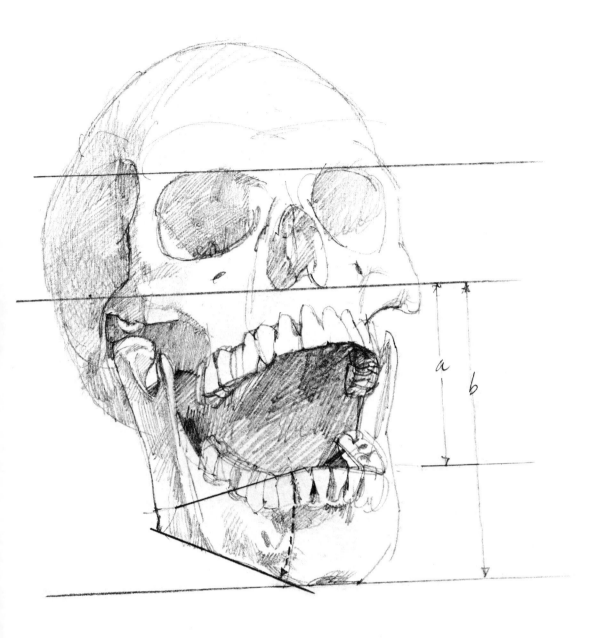

The drawings here show the changes in the structure of a skull and face brought about by the pivoting of the lower jaw when the strong masseter muscle is at work. Most people, when they open their mouths, tilt the whole head back as well as lowering the jaw. From a normal viewpoint, this exaggerates what you will notice anyhow — the angle of the jaw growing more extreme, the length of the lower face increasing, the mouth itself becoming extremely dominant.

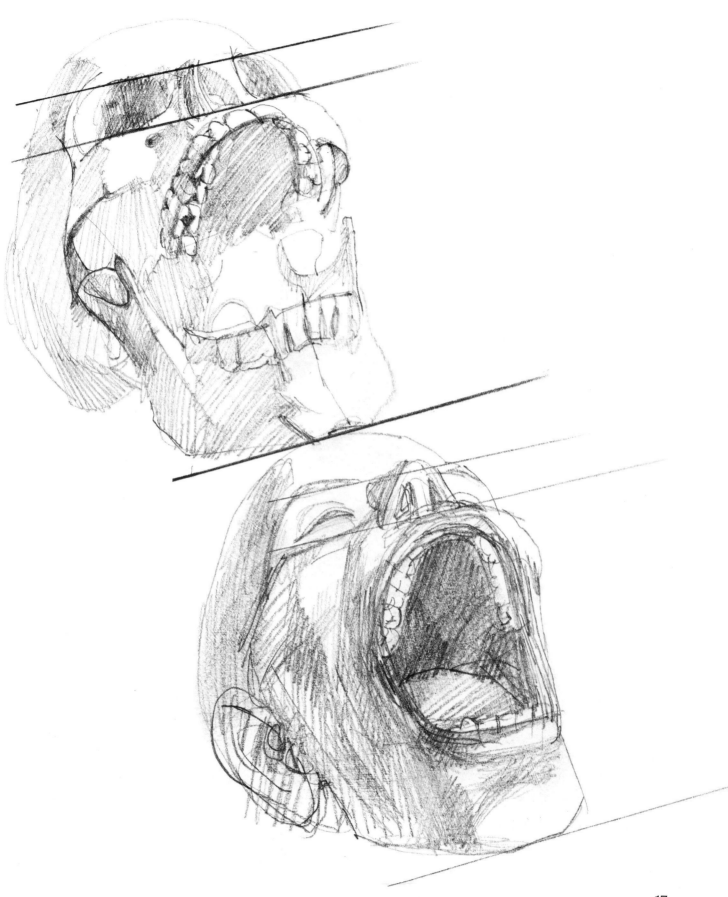

Where to begin

When you have made several drawings of skulls — becoming steadily more aware of the head's basic structure in the process — try studying a live face in repose, relating the soft, surface forms to the bones beneath.

First, spend some time arranging your model and setting up your own position. Drawing from life is made much easier if you can look from your subject to the drawing and back with a minimum of eye and head movement. For a right-handed artist, the best arrangement is illustrated opposite. The drawing board is upright on the easel, its sides parallel to the uprights of the room, and the easel is set just to the right of the sitter. If you are left-handed, reverse your position so that while working you do not have to look over your drawing arm.

If you prefer to sit, try to arrange things so that you can view your model directly over the top of the drawing board. But keep your board as upright as possible to give yourself a straight perspective view. On a tilted board a drawing easily becomes distorted, the details diminishing in size towards the top of the paper.

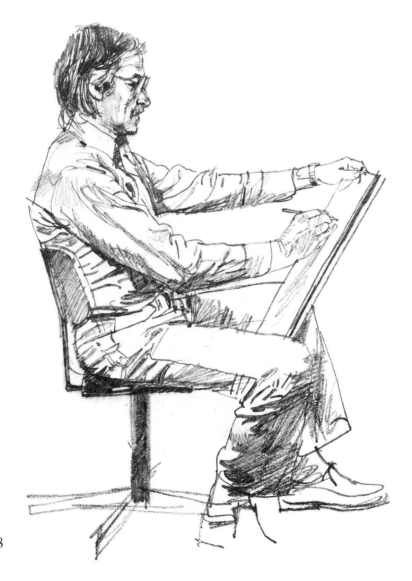

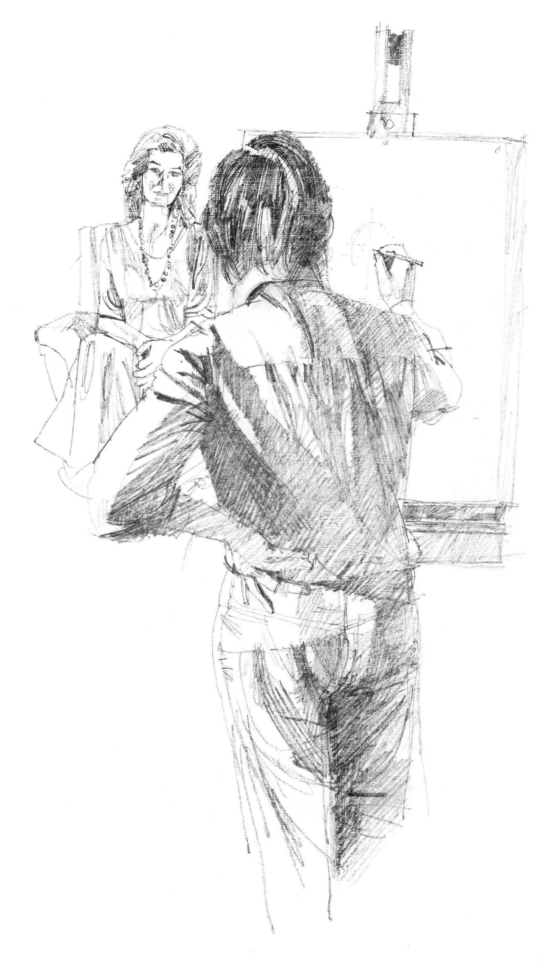

Step by step: repose

This is the first of three stages of a portrait drawing of a subject with a relaxed non-expression. Note that the pencil has been used very delicately, my intention being to build up a grid of marks which work out where features are to go. It is a searching first sketch and, deliberately, no mark or line is so dark that it cannot be changed or drawn over.

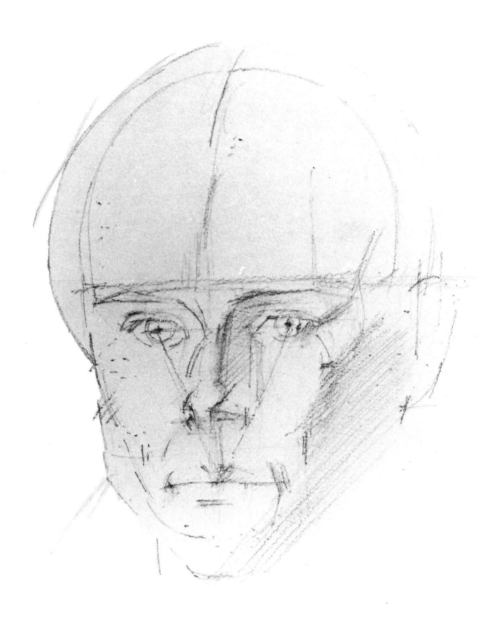

Here the search has been carried further and tone is creeping in. The word 'search' accurately describes what is happening, because anything may yet be changed. As your drawing becomes steadily more filled out, all earlier lines need to be continually questioned, so that the picture becomes both more finished *and* more correct at the same time.

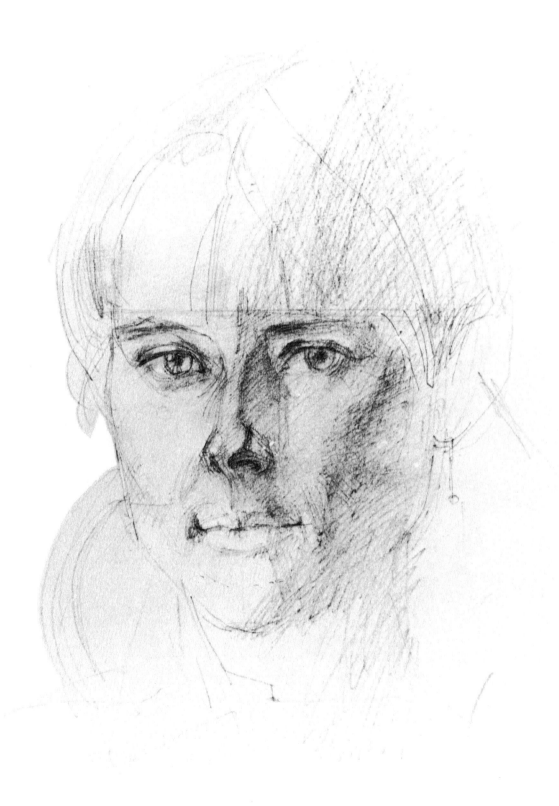

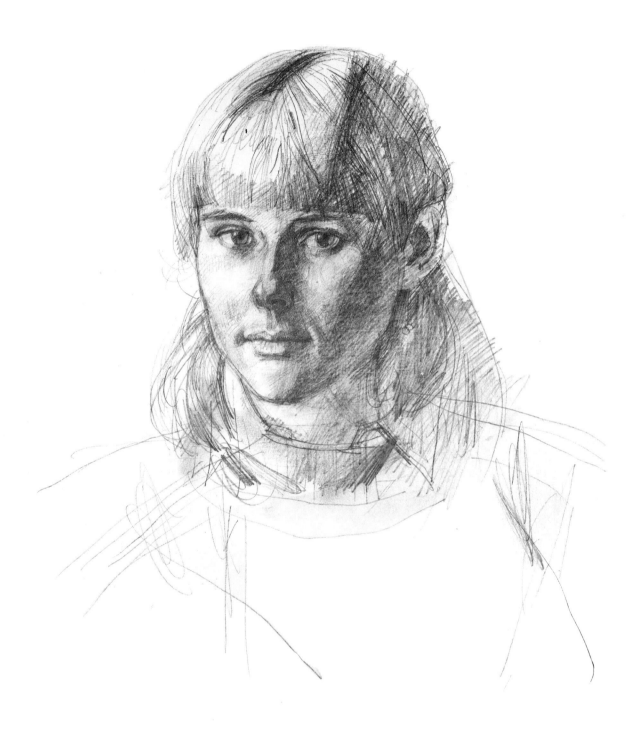

This, the final stage of the drawing, shows that the policy of searching and changing as you continue to draw has been followed to the end.

Compare the finished drawing here with each of the previous stages, and notice where the earlier, exploratory lines have been modified as the drawing progressed. Remember that the relative positions of the features and the distances between key points such as the pupils of the eyes, the eyes and the tip of the nose, and the eyes and mouth, which were established in the first stage of the drawing, should be checked constantly.

Note also that the calm, relaxed expression of this subject is conveyed mainly in the eyes and mouth and by the general absence of tension in the facial muscles.

When you are making a portrait drawing, don't forget to let the sitter rest from time to time. If your model becomes stiff and uncomfortable, his or her expression is unlikely to remain relaxed.

Step by step: the frown

Since you tend to frown when you are concentrating, making a self-portrait is a good way to learn what frowning does to a face.

When drawing a mirror reflection, it helps to prop up your head (mine is supported here by hand and elbow) so that movement is kept to a minimum. My drawing board was on an almost flat surface just in front of the mirror, so that I needed to move only my eyes to see the drawing my right hand was making.

Again, before starting to draw, spend some time arranging the set-up. Experiment with the expression itself, too, choosing one that you can maintain consistently, and choose a position where the direction of the light will have most impact on the expression. A furrowed brow is probably best lit by a strong cross light. Here it came from a window on my left, so much of the front of my face was in half shade. The white paper reflected some light back on to the shadowed surfaces, providing a rich variety of tones.

As in the last sequence, the first stage (opposite) is a collection of exploratory marks, some of which are confirmed later, others ignored. Once again, nothing is erased, and the final picture is therefore a record of the exploration process as well as a finished drawing. Notice that spectacles have their own particular shape — which you can use to help define the position of the eyes and width of head, rather than trying to fit them round the face.

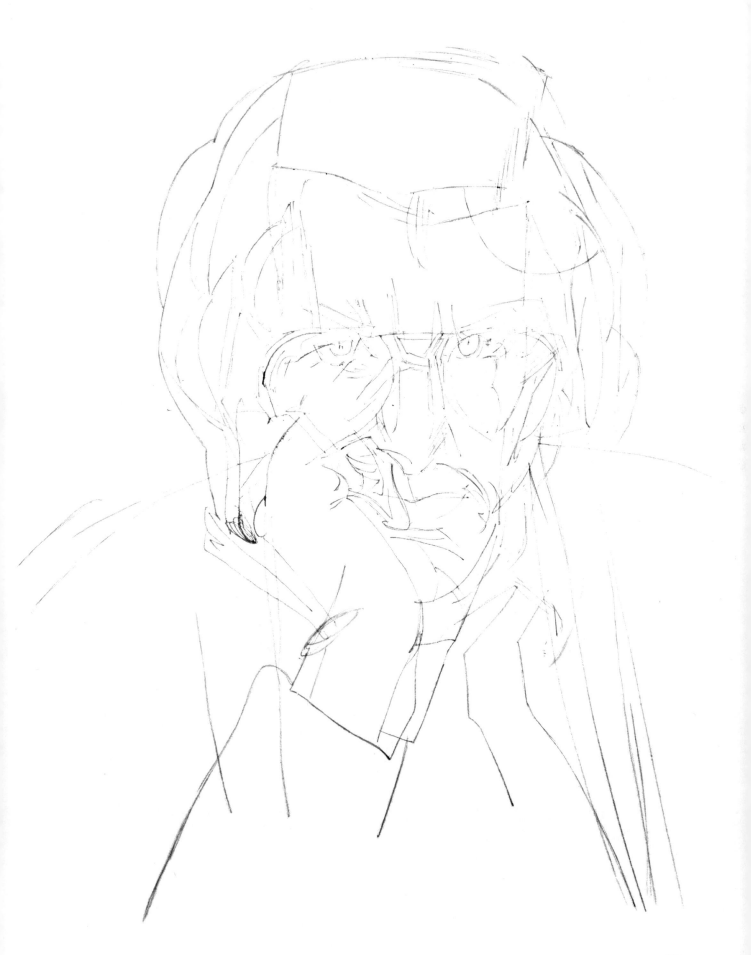

In stage two, some tone has
been added, as part of the
continuing search for the
main forms. The hand is
treated as though it and the
face were one form —
which, for the moment, they
are. All parts of the drawing
proceed together.

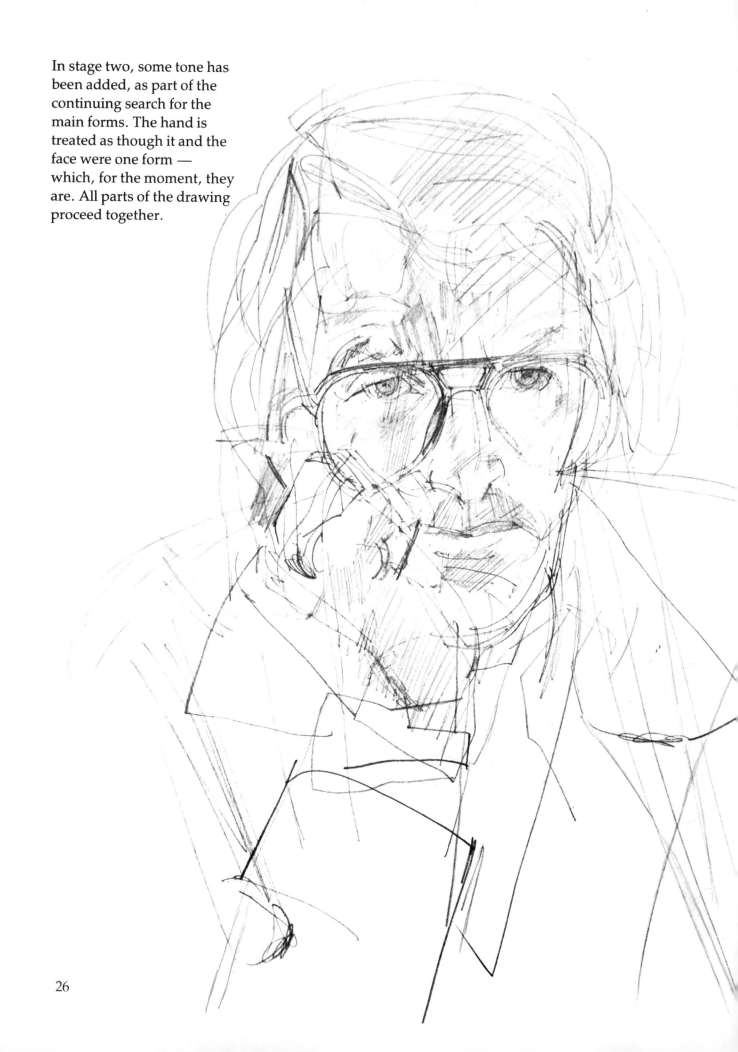

As the drawing comes to completion, the forms are solidified, and the creases caused by the frowning expression gradually defined, both by lines and by interruptions in the tone covering most of the face. Creases make not only furrows of shade but also light-catching ridges.

The smile: general

Like many expressions, a smile is difficult (or impossible) for a sitter to hold long enough for you to draw from life. A fleetingly-observed smile can sometimes be incorporated in a face reposing, and a gentle smile — particularly if part of a habitual expression of that person — can be held for a while before it looks strained. But as I wrote on page 4, a smiling face is very much more than one whose mouth has its corners turned upwards; and to understand *how* and *what* to draw, you really have to seek the help of photography.

Ideally, take several photographs of one person showing different expressions and notice how all the features change in each. Otherwise, study other people's snaps and photographs in magazines of smiling, laughing people, and learn from them to observe more closely the same expressions in real life.

The whole face is involved in a smile. The cheek muscles bunch into a clenched, rounded shape which pushes up beneath the lower eyelids, creasing the corners of the eyes, producing a familiar fold which links the nostril with the corner of the mouth. The corner of the mouth is therefore pulled outward, though not always upward. As the smile broadens, the mouth, stretched tight over the teeth, opens; and in the laugh, the jaw relaxes and the teeth part. At the same time the increased bunching of the cheek muscles narrows the eyes from beneath until, in an explosive laugh, they close almost completely.

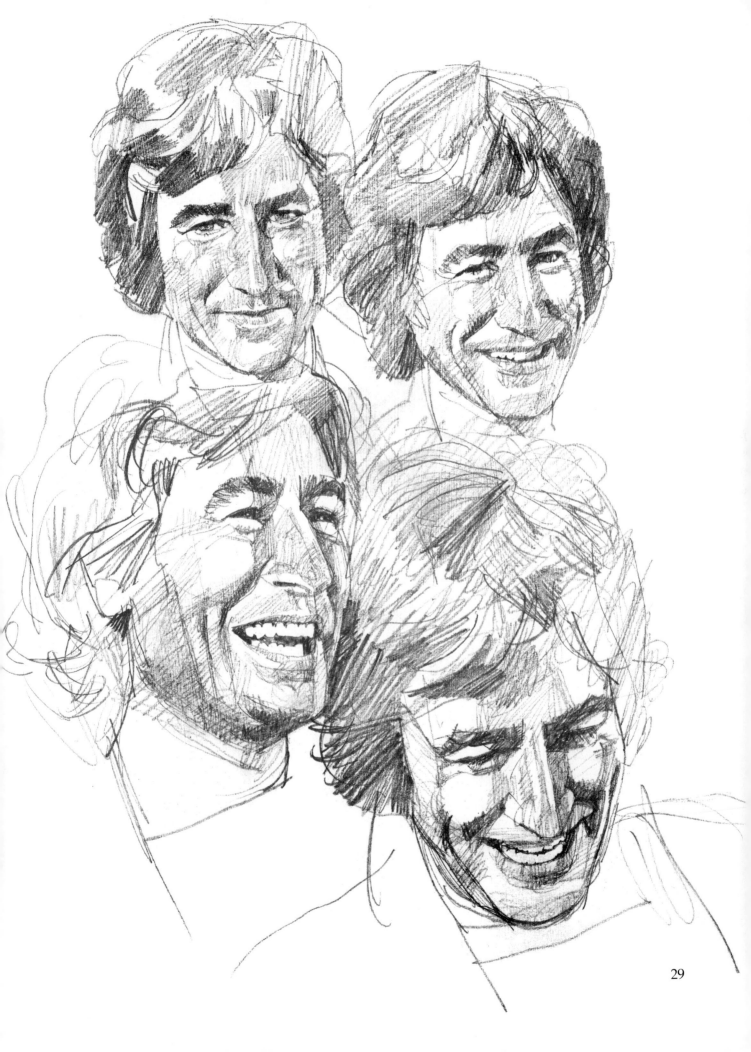

29

The smile: female

The older woman here has obviously done a lot of smiling. Habitual clenching of cheek muscles has produced deep, permanent furrows radiating from the corner of bright, alert eyes. And although her lips are closed and not upturned at the corners, the whole face is lit with a smile. The younger head is similarly animated, but the smile isn't so warm, partly because the laughter lines have not had time to develop, but more because of a lack of eye-to eye contact with the viewer. Almost always, if a smile is directed towards the artist (and therefore towards the viewer of the picture), it looks warmer and more personal; Leonardo's 'Mona Lisa' is an example.

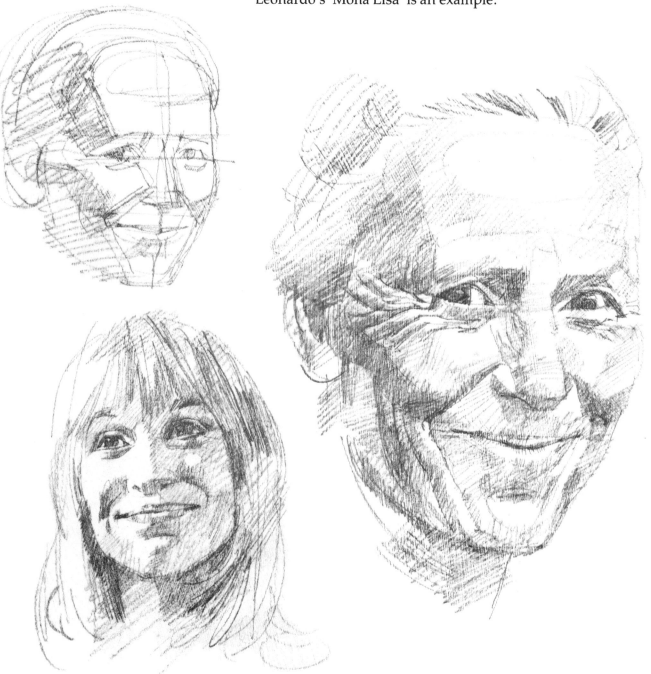

Open-mouthed smiles require careful observation of teeth, especially upper teeth, as a *whole*. The entire dental arch must be drawn in correct relation to the frontal plane of the face, or the expression will seem strange and twisted. If you want a female smile to look dazzling, leave the divisions *between* the teeth unstated — merely suggesting them through the scalloped gum shapes between upper lip and teeth.

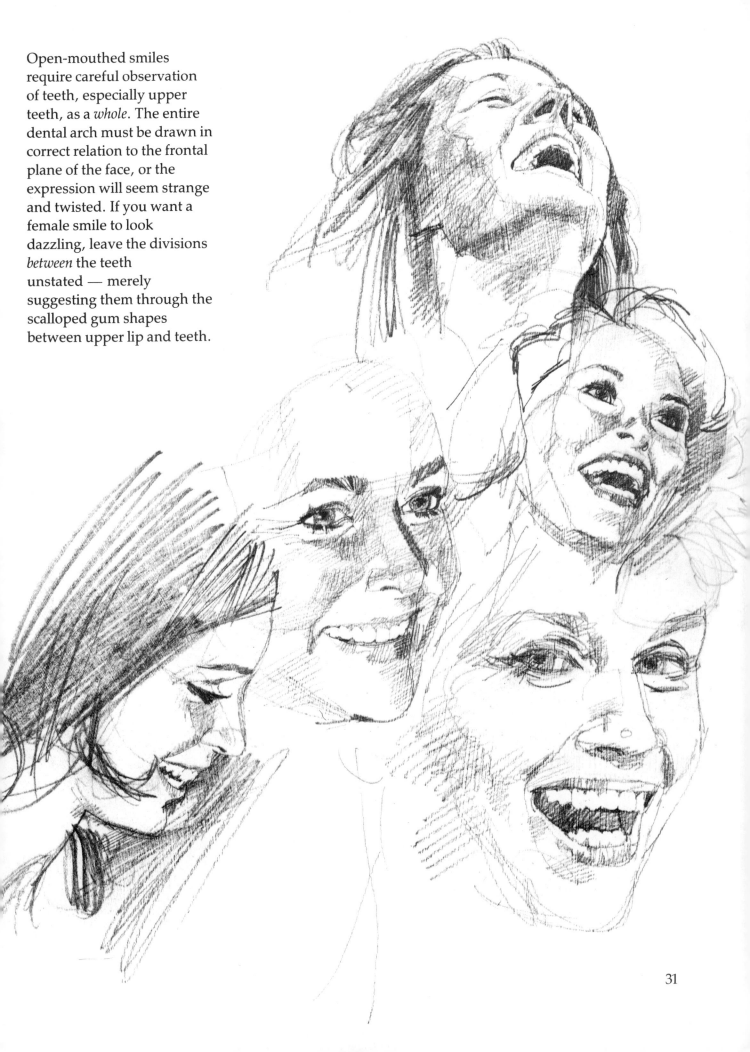

The smile: male

The same muscular mechanisms are at work on a male as on a female face, but the forms tend to be more angular, the folds more defined. The bony structure is heavier, especially at the brow ridge, the cheekbone and the lower jaw. This often results in deeper-set eyes, which narrow more readily in a smile, and more pronounced, less fleshy and rounded jaw and cheek muscles. The lips, too, are usually less fleshy, especially the upper lip, and only slightly deeper in colour than the surrounding skin tones.

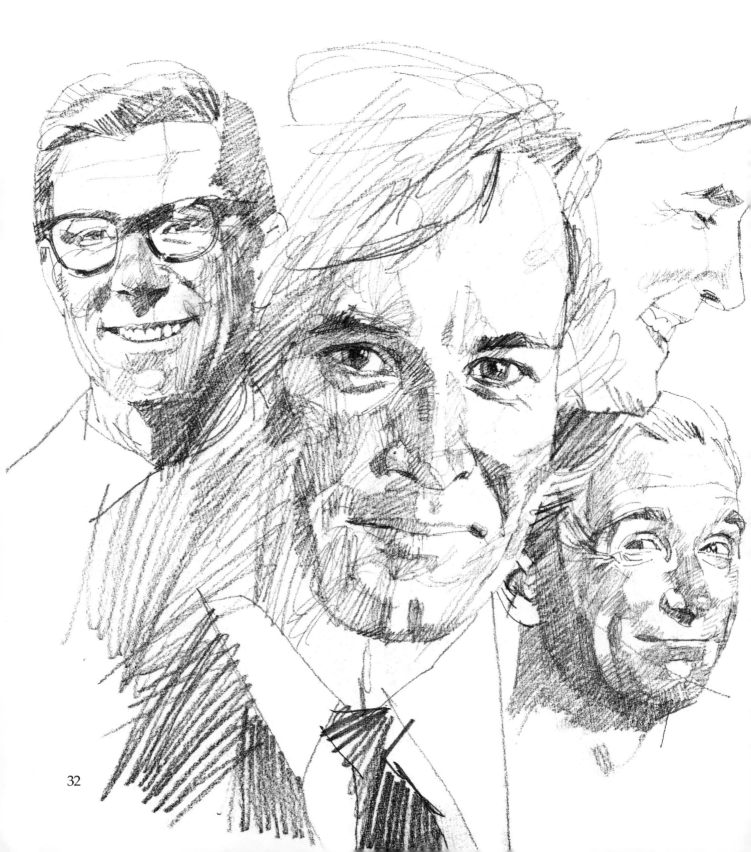

Because teeth (like the whites of eyes) are white, any changes in tone they show are subtle in comparison with the tone changes on the surrounding face. So, unless you have worked out a full range of tones for the whole drawing, it is best not to define individual male teeth any more strongly than female ones. The stronger they *are* defined in a sketched drawing, the more attention you draw to them and the less benign the smile will seem.

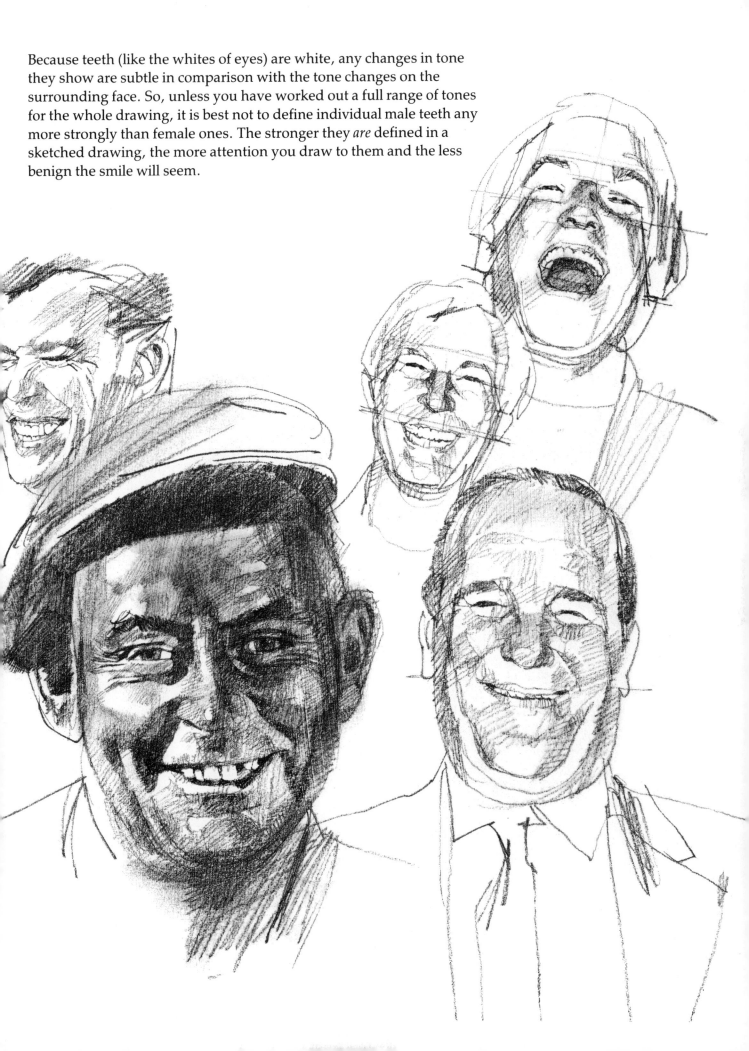

Step by step: the smile

When speed is essential (which it is when trying to capture a smile from life), charcoal is a useful medium. You will get the most out of it by drawing boldly in broad areas of tone. And since you can make charcoal alterations easily, it isn't necessary to 'search' in quite the same careful way as described in previous step-by-step sequences.

Begin swiftly and strongly, remembering that the slightest touch with hand or cloth can modify the boldest marks. Use a putty rubber for complete erasure or to add highlights to dark areas as the drawing progresses.

The three stages here show a quick transition. The last one could have stopped earlier or gone on longer; *you* have to decide when you feel you have caught the expression and therefore when to stop.

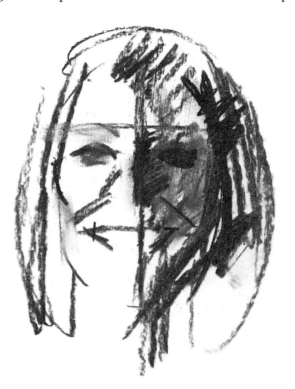

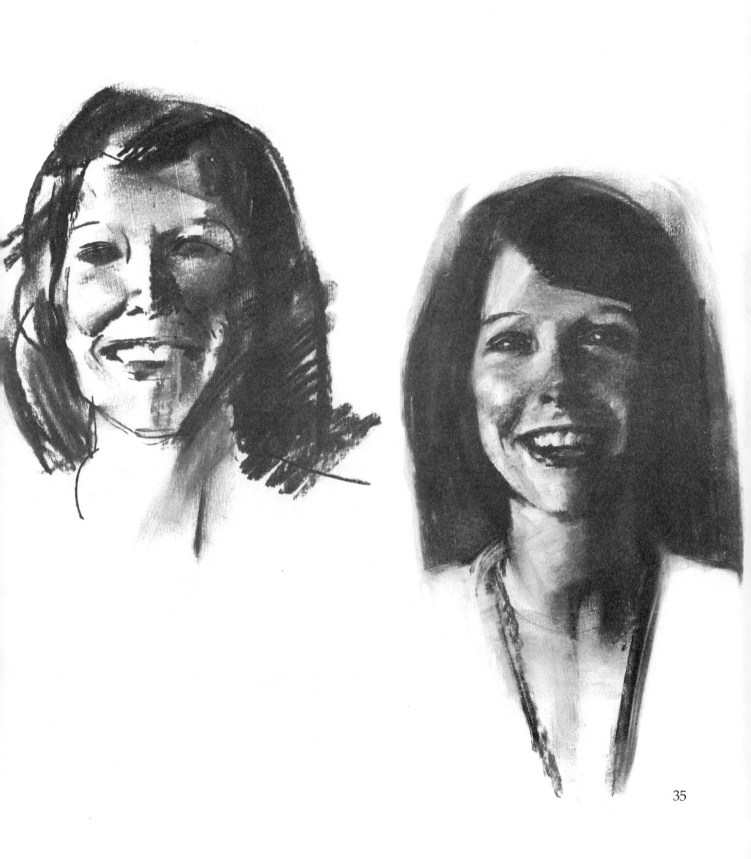

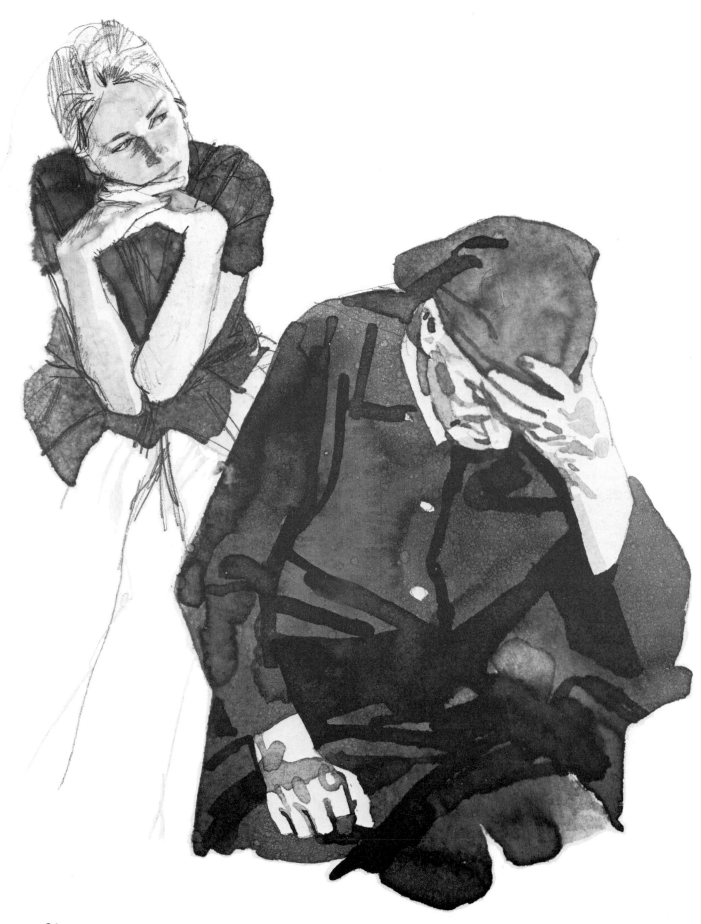

It is not only the face that conveys an expression. The set of the head, attitude of shoulders, positioning of arms and hands, all contribute. In the drawing of the old woman opposite, the face itself contributes very little. Even when (in a three-quarters back view, for example) the face is almost hidden, an expression can be conveyed by the tension or slackness of neck and shoulders.

Watch how people use their hands to support, conceal and accentuate facial expression

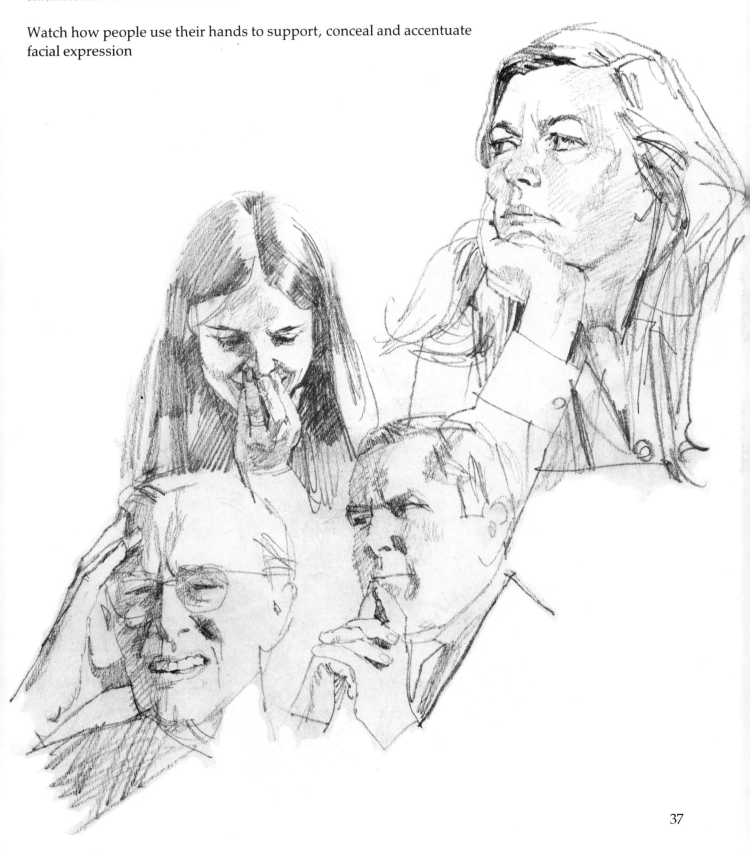

Anger and aggression

A frowning brow is an obvious component of an angry face, but the mouth plays an important role too as the expression deepens from displeasure into active anger or aggression. When shouting is involved, the mouth often becomes square as the outer edges of the lower lip are pulled downwards and outwards.

The bottom drawings on this page show the exposure of lower teeth, which is characteristic of non-vocal aggression.

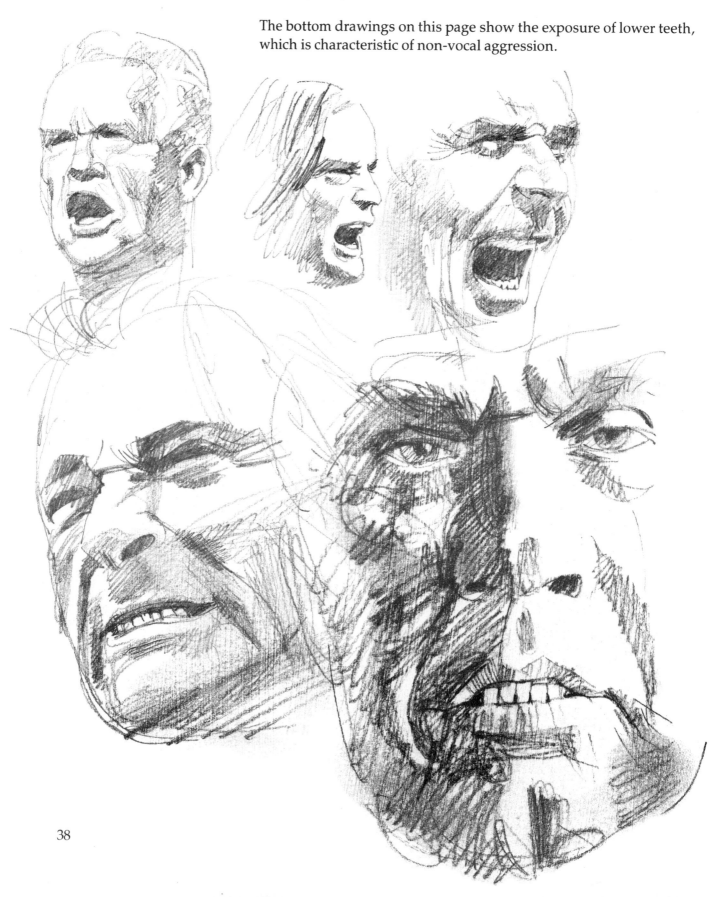

The two drawings here demonstrate how close an expression of anger may be to one of extrovert delight. Only the lower lip's outer edge and the eyebrow shape distinguish one from the other, the jaw opening and the bunching of cheek muscles being identical.

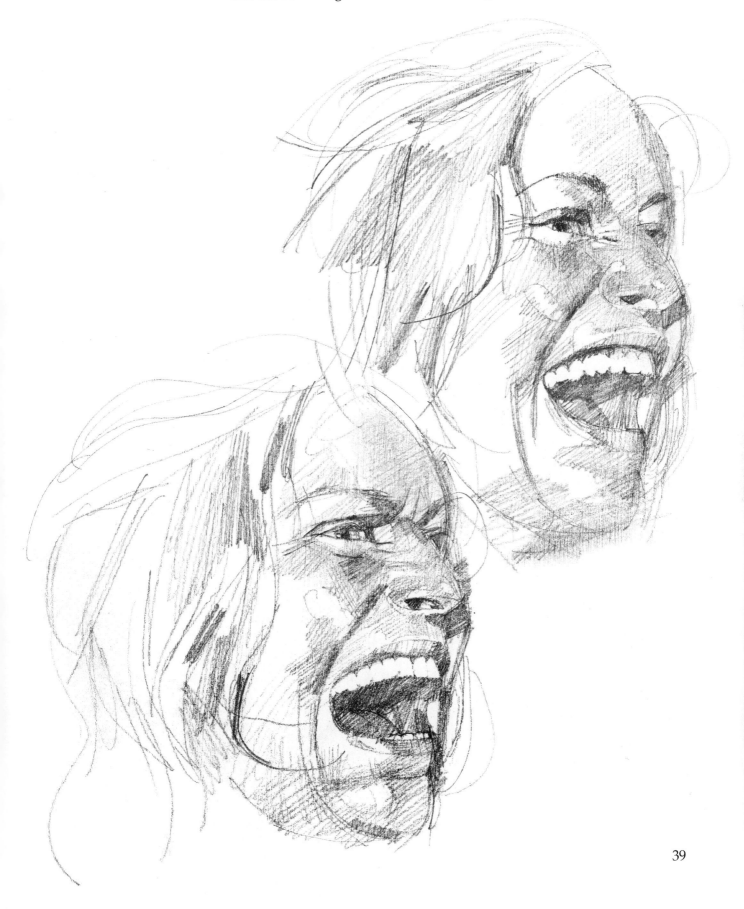

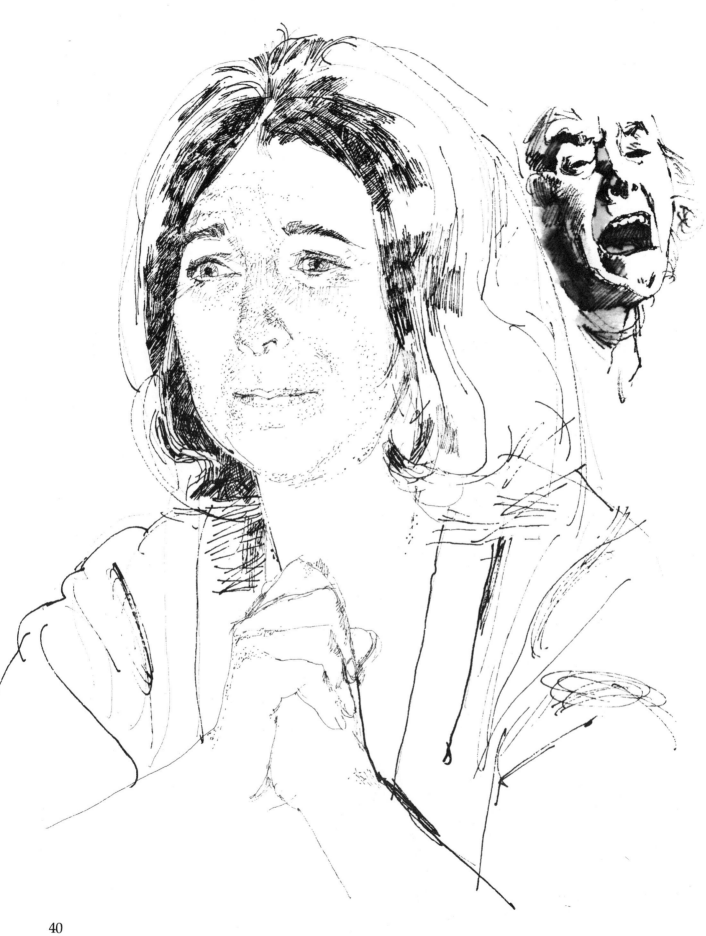

Sorrow

The traditional face of sorrow is exemplified in the theatrical mask of tragedy — the face of a tragic clown, with downward-sloping eyebrows and a mouth pulled down into an arc. Real life is rarely so extreme. The eyebrows often meet together in a frown. The mouth may adopt a variety of shapes, but a frequent feature is muscular bunching at its lower corners, which gives a grim set to the cheek (below, right). The fine pen drawing shows a grimace of pain.

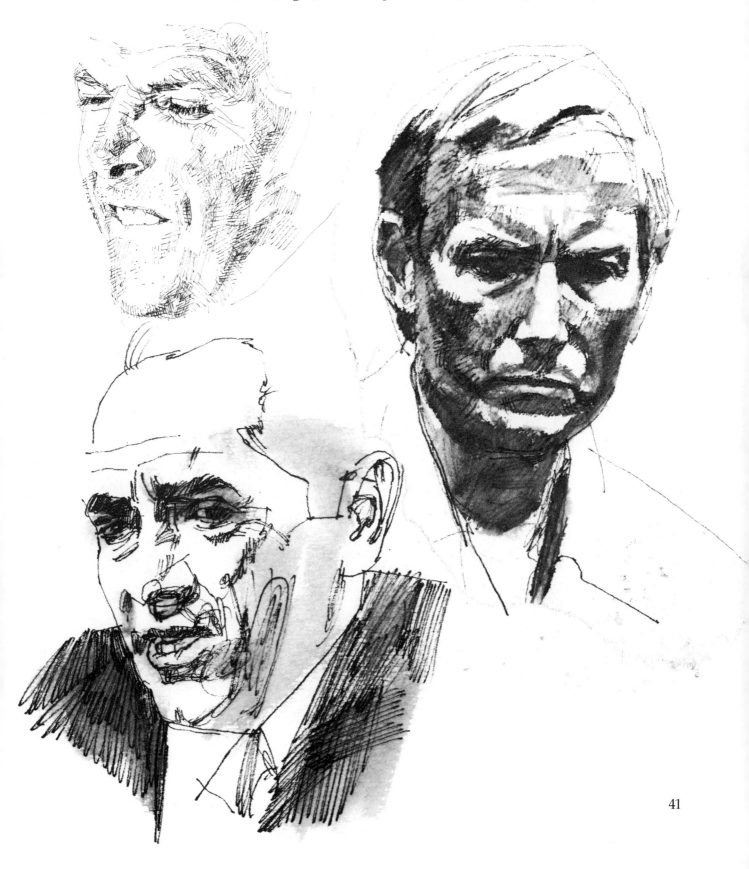

Fear

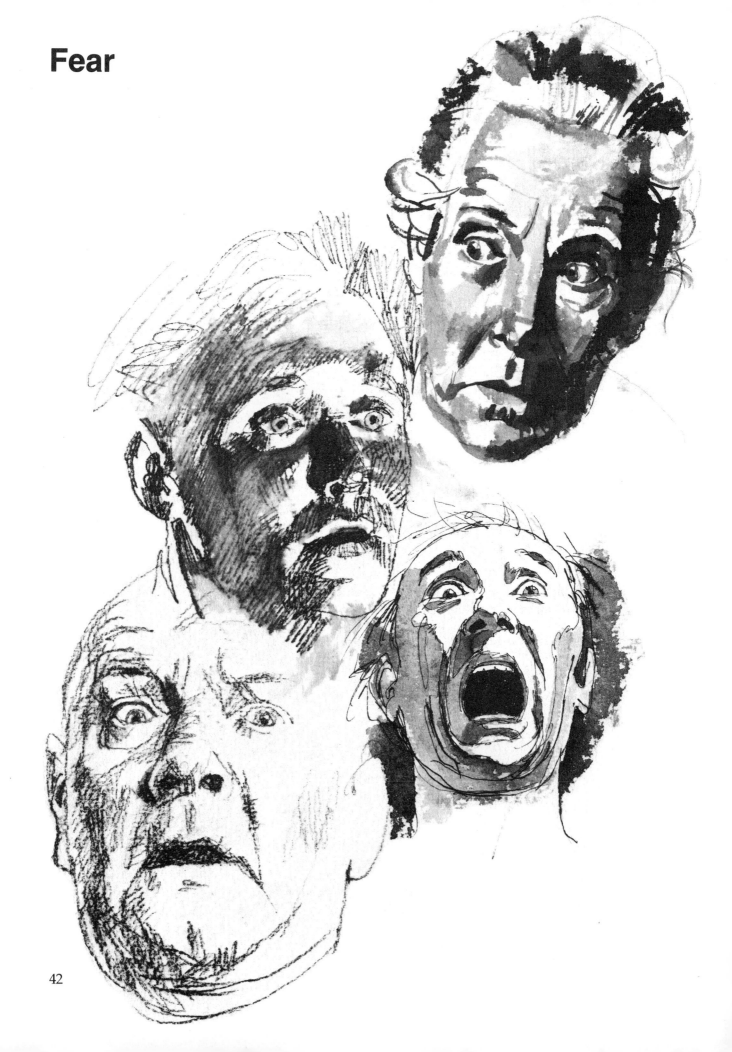

The salient feature of the face of fear is the widely opened staring eye. Whether the eye opens to see more clearly that which is fearful, or to scare it away, is uncertain, but many animals stare similarly when frightened. Although the mouth may open too, it will be with a passive dropping of the jaw, not exposing the teeth — unless the fear is sufficiently extreme to produce a scream of terror.

If you light the face from below, the feeling of fear will be dramatised.

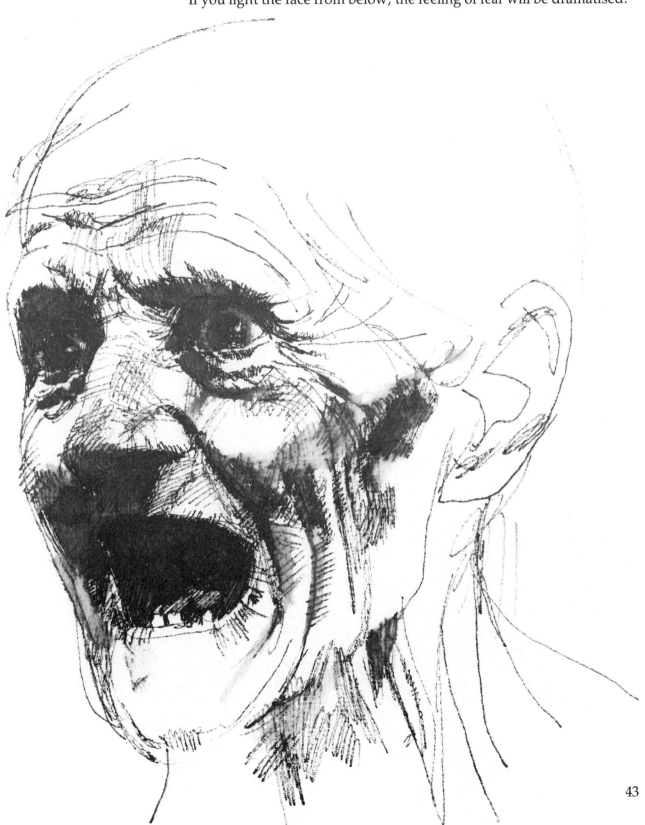

Other expressions

The human face is capable of many more expressions than the primary ones already described — combining the basic facial movements in a bewildering variety of permutations. Here are a few of them. The strained face below is that of a competing athlete; the others are self-explanatory.

Never assume symmetry in any of the features. The eyes, for example, are often very different from each other. The close-up (centre opposite) demonstrates that when eyes are turned sharply sideways, the one nearer to the object looked at is usually more open than the other and its pupil further from the corner.

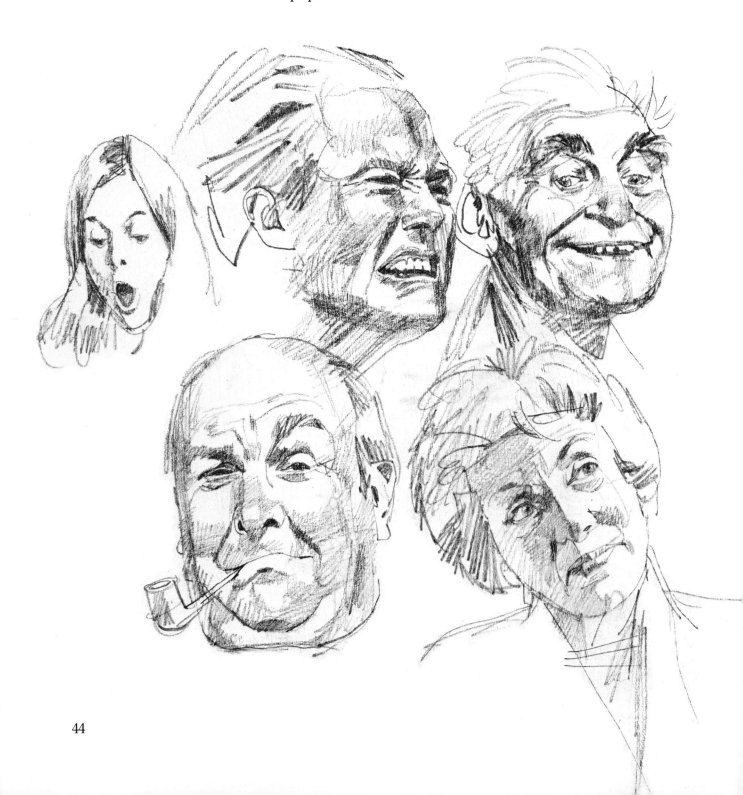

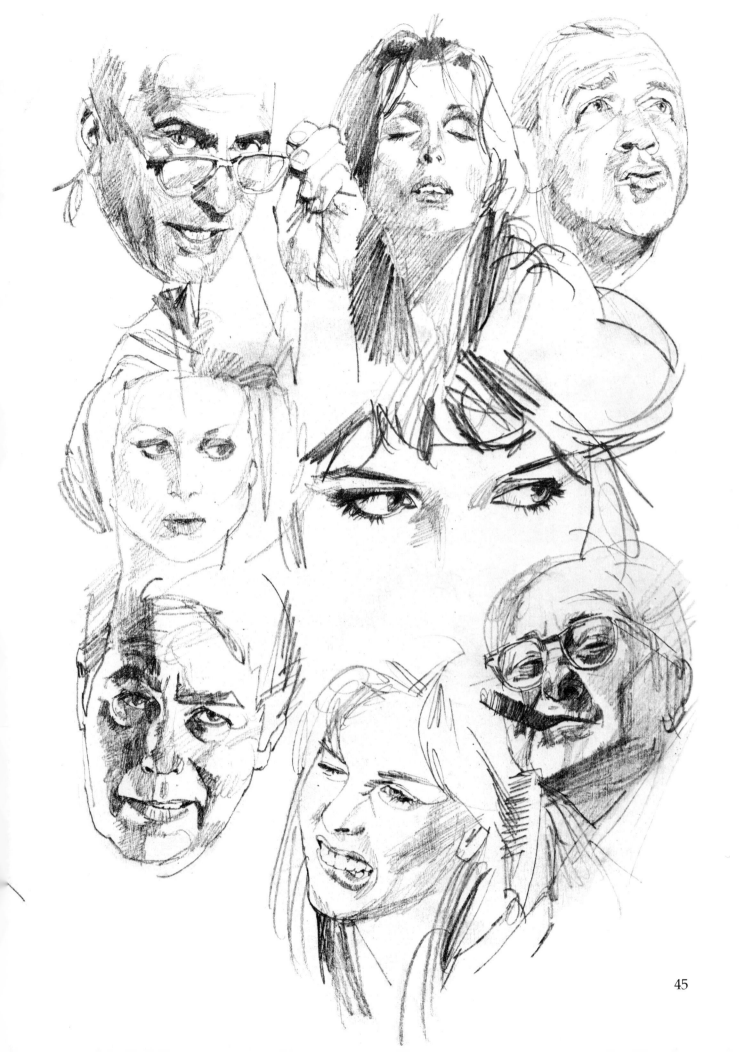

Old age

As a face ages, skin loses its elasticity, muscle loses its tone, and the creasing caused by expression becomes permanent, recording habitual moods and attitudes to life.

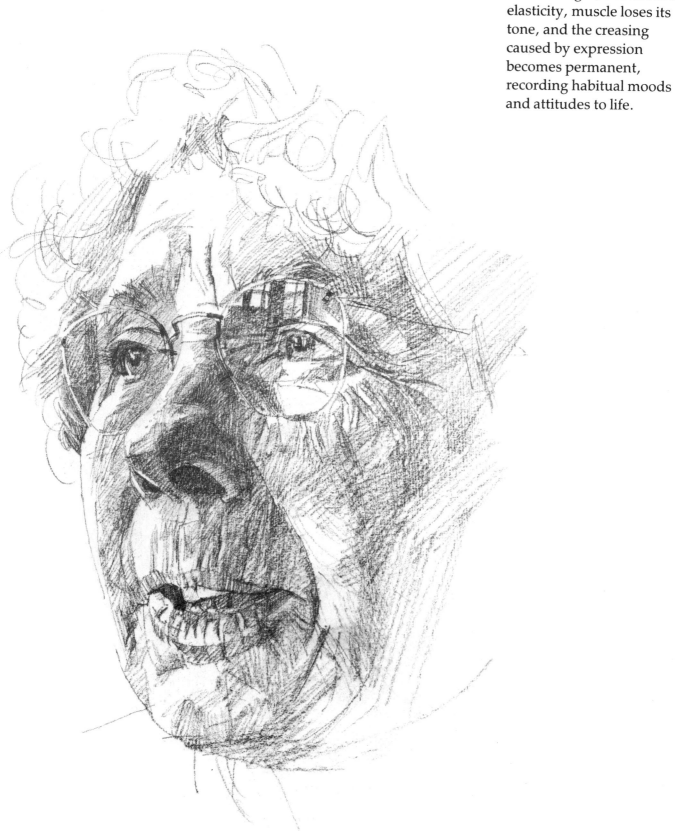

Searching out these etched patterns is fascinating, but don't forget the underlying bone structure, which is often more evident in old age. Also look for fat deposits, which tend to concentrate around the jowls and neck but may also puff out around eyes and cheeks.

In old age the differences between men's and women's faces become less obvious; sometimes only the distribution of scalp and facial hair makes the sex identifiable.

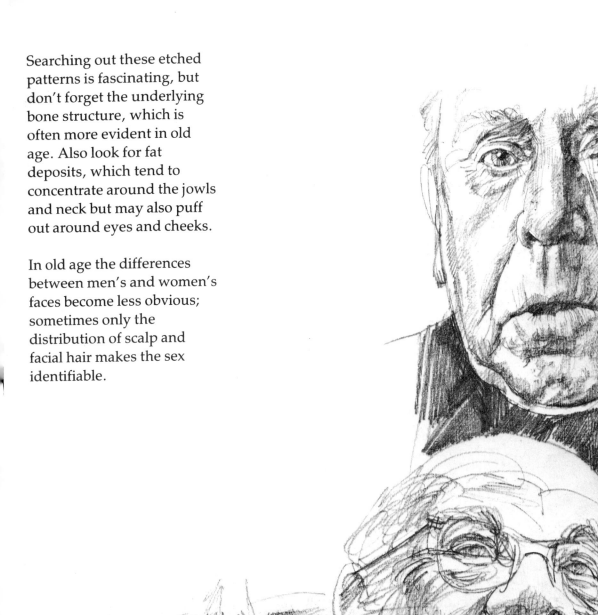

Childhood

Here, by contrast, are some drawings of the rounded, unmarked faces of children.

Character has not yet emerged and the bones of the skull are not complete, but from its earliest months a child's range of expression is wide and vivid.

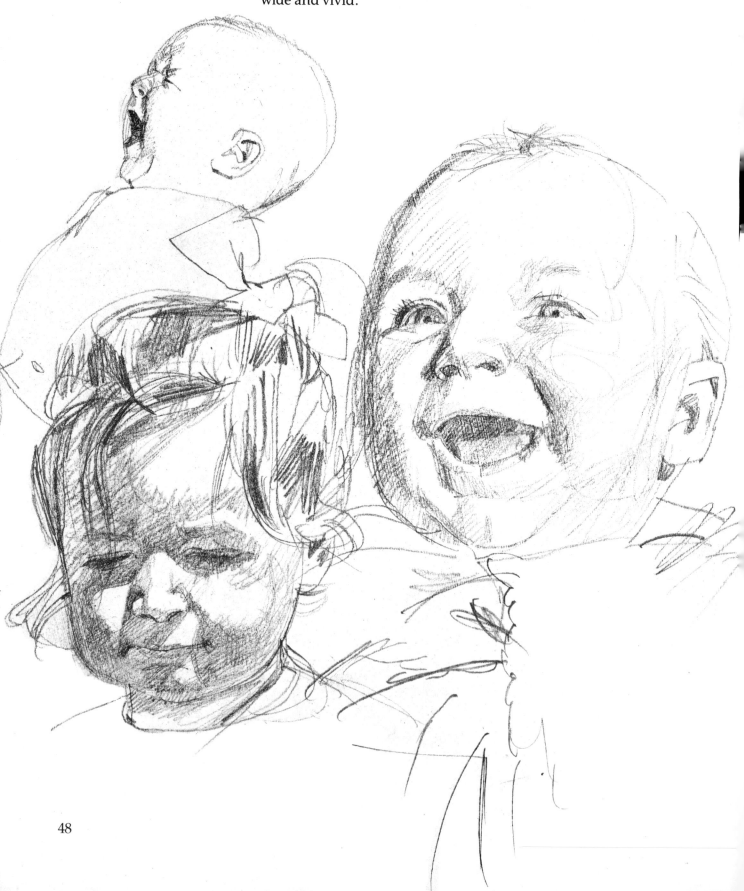